The *Lost Work* of *Will Eisner*

EDITED BY:
ANDREW CARL, JOSH O'NEILL, AND CHRIS STEVENS

THE LOST WORK OF WILL EISNER

WILL EISNER
Artist & Author

Edited by Andrew Carl, Josh O'Neill, and Chris Stevens

Printing plates and scans supplied by Joseph M. Getsinger'

Cover design by
James Comey, Peter & Maria Hoey
Book design by
Peter & Maria Hoey

Associate Publishers: Corrie Allegro, Japhet Berlin, Kim Kui Chung, Len Ciccotello, Joseph Kaisler, Nat Karmichael, Sean Kleefeld, Taroh Kogure, Jay Magnum, Justin Park, Rukesh Patel, Richard Pini, Mark Rodgers, Darin Ross Stater, and Joseph Wrzos

Published by Locust Moon Press
Andrew Carl, Editor-in-Chief
Chris Stevens, Creative Director
Josh O'Neill, Publisher
4700 Kingsessing Avenue, Philadelphia, PA 19143
locustmoon.com

Locust Moon would like to extend their deepest thanks to Will Eisner Studios and the Eisner estate
for their support of this project and their stewardship of the legacy of Will Eisner.

First edition, July 2016. Printed in China. ISBN: 978-0-9973729-0-8

Uncle Otto and the Strange Metamorphosis of Harry Carey

By Denis Kitchen

Prior to the recent discovery of the "Getsinger Find" printing plates discussed elsewhere in this volume, Will Eisner's early *Harry Karry* and *Uncle Otto* weekly strips were virtually unseen. They are among the least documented components of Eisner's long, prolific, and illustrious career.

In 1936 Will Eisner, while still a teenager, following a tip from a cartooning classmate Bob Kane, got his first professional comics gig contributing to *WOW, What a Magazine!* After the short-lived magazine folded, and briefly finding comics work elsewhere, the savvy nineteen year-old initiated a business partnership with *WOW*'s out-of-work editor Samuel "Jerry" Iger. They formed the packaging studio Eisner & Iger to provide editorial content for comic book publishers during the industry's infancy, a period of very rapid growth. It was during that studio's relatively short but productive existence that the strips collected here were created. *Uncle Otto*, bylined by the fictitious Carl Heck, is not an obvious product of Will

Eisner. But though he is famous for his more "realistic" adventure strips like *Hawks of the Seas*, his long run on the now legendary *The Spirit* (1940-52), and the later groundbreaking graphic novels like *A Contract with God*, many of Eisner's early works were comical in style and theme. *Uncle Otto* is in the tradition of pantomime strips, a relatively scarce sub-set in the balloon-happy comics world. In a handful of the strips reprinted here the supporting characters may say a line or two, but Otto himself is invariably mute.

When Eisner created the *Uncle Otto* strips, which started in 1937, the best-known pantomime strips were Otto Soglow's *The Little King*, launched in 1931, and Carl Anderson's *Henry*, started a year later. *The Little King*, coincidentally, was reprinted in issues of *WOW, What a Magazine!* My unprovable theory is that, as a subtle homage to those silent strips' creators, the youthful Eisner gave Anderson's first name to "Carl Heck," and Soglow's first name to "Uncle Otto."

The bell-shaped Otto even bears a physical resemblance to the rotund, crown-

wearing Little King, and Otto's distinctive narrow hat is reminiscent of the tin can always precariously balanced on the head of Frederick Opper's Happy Hooligan from the earliest days of newspaper comics.

Uncle Otto was popular enough that he is the featured character on the very first issue of the oversize *Jumbo Comics* (September 1938), depicted in four diving panels, two of which mirror the diving gag reprinted here. He appeared in *Jumbo Comics* for thirty-two issues in all, periodically appearing in cover cameos.

Fiction House, an important client of the Eisner & Iger shop, published *Jumbo Comics*. Because Eisner early on was required to produce so much material singlehandedly for the big customer, he said he actually "deliberately adopted a crude rendering style for some stories," so that the client didn't think the content relied so much on a single creator. There are certainly stylistic aspects of *Uncle Otto* that are homely, and not associated with Eisner's recognizable style. Aside from deliberately altering his pen work to some degree, it's very possible that someone else in the Eisner & Iger shop was collaborating on at least a portion of these strips.

The *Harry Karry* strips in this collection are of particular interest to students of Will Eisner's work because a steady maturation of his style is evident prior to the singular creation of *The Spirit* in the near future. And very strangely, within ten weekly strips, his drawing style dramatically—instantly—evolves from relatively simple and cartoony to dark, moody, and illustrative within a single strip.

This compilation is restricted to the fifty-two strips that could be reproduced from the unlikely discovery of the original zinc printing plates. The possible incompleteness of the collected material is suggested by the opening description

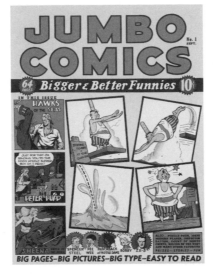

Jumbo Comics #1, published in September of 1938, prominently features Eisner's Uncle Otto character.

in the first strip, referencing a prior plot. But given the illogical elements present throughout the known strips, it is possible the published strips actually begin as indicated here.

Everything about the strip is fluid; even its name. When Eisner first created the character in January 1935 he was seventeen years old and the "famous international detective" was named Harry Carey. The internally rhyming name was likely taken from the popular silent film cowboy Harry Carey. It may also have been wordplay on the Japanese suicide ritual *hara-kiri* (often misspelled as *hari-kari*). Eisner initially created the humorous detective for a school publication at DeWitt Clinton High School in The Bronx. As one might expect from such a young creator, his early efforts (as seen on the following page) were far from perfect. The panels were overly wordy, the uneven lettering changed sizes without reason, and the story, such as it was, was frantically paced. But the character design and style in Eisner's original conception are not significantly different from the strips beginning the *Harry Karry* section of this collection.

Sometime a bit later in 1935 Eisner redrew his *Harry Carey* samples. In the second set (seen on page 6) he significantly altered the strip's width-to-height proportion. The Bovnian premise remains and certain elements, such as the eavesdropper falling through the opened door, are virtually identical to the first effort. There is an interesting detail in each of the two separate falling eavesdropper panels: in the backgrounds to each a circular window is visible, the second time drawn with more depth and detail. These are curiously identical to the distinctive round window that will later become a trademark of the cemetery hideout of Denny Colt, alias The Spirit.

Harry Karry made its official debut as the inside front cover of *WOW, What a Magazine!* No. 2 (August 1936). By the time the strip first appears in a professional publication the character's last name has been changed from Carey to Karry, probably a prudent calculation that western actor Harry Carey might wish to protect his proprietary interests.

A "brief history" reveals that Harry was the kind of detective who took the law into his own hands: after he "lost his shirt" in a Chinese laundry scam he tracked the villain Holin Wan "thru the darkest parts of Chinatown" and shot him dead. The first high school effort, signed "Eisner," is reprinted at the end of this introduction.

Harry and the Bovnian eavesdropper are prominently featured on the cover of *WOW* No. 3. For the first time the strip is credited to "Bill Rensie" (Eisner backwards). In the single page story the secret agent, after confessing, makes his escape using the same silly pop-out boxing glove used in the opening strip of the weeklies collected here. In the fourth issue of

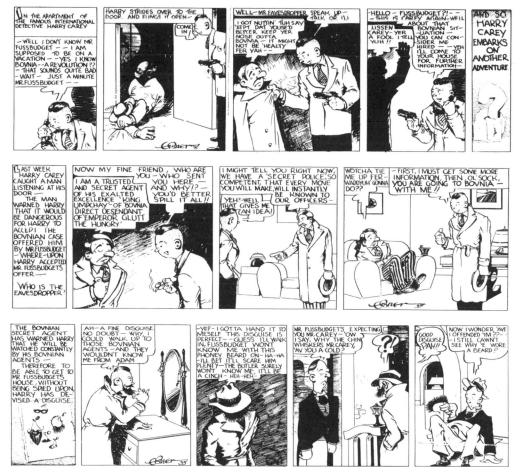

Early *Harry Karry* strips (then called *Harry Carey*), published in 1935 in Eisner's high school newspaper.

WOW, after Harry's paranoid client Mr. Fussbudget inadvertently smashes the detective with a giant vase, the last panel announces, "Next Month we will meet Mysterious Max." But there were no more issues and we never see Max.

Soon after *WOW* folded, as noted earlier, Eisner began his partnership with its former editor Jerry Iger. Like *The Flame*, another Eisner creation in *WOW*, which evolved into *Hawks of the Seas*, *Harry Karry* was another creation the fledgling comics packagers would continue to commercialize.

Eisner & Iger grew to employ about fifteen artists, letterers, and writers by 1939, but it began modestly with just the two founders in a cramped ten-foot square New York City office. Iger, though a rudimentary cartoonist, was principally the shop's salesman, and in order to impress prospective clients with the studio's perceived roster, the prolific Eisner drew strips under

various pseudonyms, such as Carl Heck, W. Morgan Thomas, and his backwards name Rensie. The *Harry Carey/Karry* credits evolved from "Eisner" at the strip's inception to "Bill Rensie" in *WOW*, and finally strips produced under the Eisner & Iger umbrella appear signed "Willis B. Rensie."

The opening strip in this compilation continues the architectural detail in Eisner's initial two 1935 samples: Harry for a third time opens a door to a stranger, and again a circular window, now more prominent, is in the background, presaging the recurring visual element in *The Spirit*.

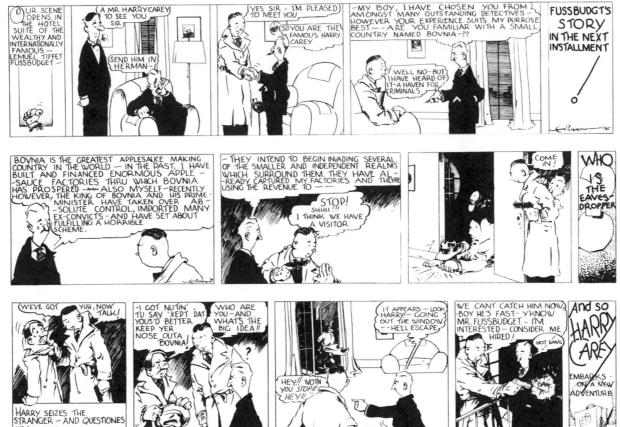

More strips from Eisner's days at Dewitt Clinton High School.

of *Harry Karry*, including such slapstick elements as the pop-out boxer's glove and the Popeye-like flying fists of pint-size body guard "Slappy" McGurk.

Ebony White, the long-time African-American sidekick to The Spirit, is a controversial character for exhibiting certain racial stereotypes, though such depictions were arguably typical of the era in all levels of entertainment, and critical views of Ebony are offset to a large degree by the context of an otherwise well-rounded, sympathetic, and often heroic character. But the

Fans not familiar with Will Eisner's earliest work may be surprised by how cartoony his style is for both *Uncle Otto* and the earliest *Carey/Karry* strips, but Eisner freely acknowledged in various interviews over the years that one of his first influences was Elzie Segar, the creator of *Popeye*. The Segar influence is evident in the opening eight strips characters Eightball and the fortuneteller, fortunately only briefly introduced in *Harry Karry*, fall into a cringe-worthy category defensible only by Eisner's very young age.

If the long-white-bearded judge presiding over *Eightball's* chicken theft case looks somewhat familiar, he predates by a year Gene Ahern's similar "Little Hitchhiker" character in *The Squirrel Cage*, who in turn inspired R. Crumb's similar-looking fly-by-night guru Mr. Natural.

Right after the cartoony trio of Harry, Slappy, and Eight-ball "venture into the [ahem] darkest part of town" in the eighth strip, something quite startling and remarkable happens. The "plot" to this point has already been extraordinarily herky-jerky, but at the beginning of the ninth strip, *Harry Karry* reinvents itself dramatically. The action begins with the still cartoony Harry talking on the phone on the left side of a split panel, while on the other side an unnamed military or government figure tells Harry he's been "commissioned as American Military Attaché to Chesterland—prepare to leave immediately." The official talking to him is drawn in a more realistic style. The next panels are far more jarring; they immediately assume a literally darker and more atmospheric tone. We have abruptly fallen into a comic strip rabbit hole where internal reality is turned on its head.

The tenth strip begins by announcing, "Last Week Harry Karry received a new assignment—Meanwhile in another country, Chesterland, ZX-5 an intelligence agent, receives orders from another agent." Yet even though Harry has been reassigned to the very same country, Chesterland, where we would logically expect him to reappear, we never see or hear of him again. But the reinvented strip inexplicably continues to be called *Harry Karry*.

The forty-some strips following the drastic transformation are as fast-paced and convoluted a story as can be found anywhere. At the beginning of a career that

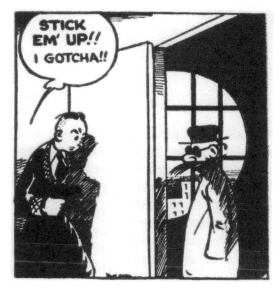

would span another seventy years, Will Eisner was just developing the storytelling and artistry for which he is now legendary, and Eisner himself was quick to acknowledge his early shortcomings. Flashes of the mature Eisner appear tantalizingly in the ZX-5 sequences. The mostly pedestrian panels are occasionally broken up: the worm's eye view through a barred cellar window, the wordless angled panel of a dark figure in an alley, and a few similar, now-Eisneresque elements poke through. Sometimes characters and scenes are inked with considerable care and other times, suggesting periodic work overload, they are clearly finished in haste.

Eisner's apparent fascination with spies and secret agents during the pre-War period is evident in the variants of ZX-5 he produced, including K-51, and the *Espionage* series in *Smash Comics* that featured the mustachioed and monocled agent Black X, later Black Ace. *Jumbo Comics*, starting with its first issue in 1938, published separate adventures of *ZX-5*, drawn early on by Eisner. In extended adventures lasting sixty-nine issues, Agent ZX-5 fights Nazis and spies, eventually morphing into a private investigator.

At its best moments the *Harry Karry* strip conjures *Secret Agent X-9*, the popular syndicated strip originating in 1934, written by Dashiell Hammett and illustrated for the first two years by Alex Raymond (who drew it concurrently with *Flash Gordon* until being forced to abandon his involvement in *X-9*). *Secret Agent X-9* likely inspired the creation of *Harry Karry*, or at least its sudden transformation. Like ZX-5, the hyphenated X-9 was a nameless secret agent who worked for a powerful, never-named governmental entity. And if the upstart Eisner was

attempting to learn some chops from Raymond's smooth style early on, he picked the right adventure strip artist to emulate.

Working around the clock under extreme deadline pressure at the fast-growing packaging studio, Eisner was churning out volumes of product, and the syndicated weekly *Harry Karry* seems to have been written on a virtual strip-to-strip basis without a cohesive outline and a cast of two-dimensional ciphers. Character development was not a priority in the studio's chaotic product-cranking environment: ZX-5 is the presumptive new hero but readers are provided virtually no information about him, his allies, or his adversaries. No one was paying attention to copy editing, either: punctuation is wildly inconsistent, and the word "fishy" is misspelled twice.

A capsule summation [spoiler alert] reveals how densely and inanely the strips are plotted. Immediately ZX-5 sees fellow agent B4-X killed, but he himself is merely knocked unconscious by the killer. ZX-5 tracks the spy nest, wounding an assailant who tries to kill him en route. He captures a spy who first tries to knife him. The female head spy, possibly a princess, assessing ZX-5's damage, decides without any basis that she will uncover him at an upcoming masquerade ball. ZX-5 likewise baselessly assumes he will meet her there. Meanwhile ZX-5 captures two of her other spies at an airport hangar. To silence her imprisoned comrades, she has a poisoned cake delivered to their cell. Though suspicious, ZX-5 allows his prisoners to eat it and die in agony. ZX-5 arrives at the ball looking like Mandrake the Magician wearing a Spirit mask. He sloppily reveals his cover to an ally. The "woman spy" (eventually called Magda) lures ZX-5 to an isolated house in the countryside. He shaves his mustache and dons fake whiskers (oddly paralleling the cartoony Harry Karry in the third strip) to arrive "in disguise."

As ZX-5 disarms Magda's chauffeur, her escort Alexei stabs ZX-5 in the back. She calls a Dr. Fields who arrives and proclaims the knife wound to be a "bad case—

very serious." Magda demands he operate immediately with no surgical equipment other than hot water and towels. ZX-5, exhibiting remarkable recovery skills, soon regains consciousness and mobility, but he and Dr. Fields are held prisoner. Plans for a new army plane at the hangar are inexplicably in ZX-5's safe and Alexei and the driver are ordered by Magda to drive there, crack the safe, and steal the valuable documents. In the process the pair kill a guard. Magda, whose spy ring has been ruthless, is suddenly concerned the police will be on their trail. Dr. Fields easily escapes to warn authorities, while ZX-5, who could have escaped too, stays behind. Alexei and the driver betray Magda, confront and kill the head of local espionage, steal the airplane secrets, and try to extort Magda. ZX-5, whose arm is mysteriously in a sling from his near-fatal back wound, manages to subdue the stout chauffeur, but not Alexei. As police storm the hideout, Alexei machine guns an undetermined number of policemen as the final surviving strip ends on a cliffhanger. Whew!

The disparate elements comprising the full body of work titled *Harry Karry*, spanning at least five years, has not yet been pieced together. It is not known at this time if the syndicated weekly version began earlier or lasted longer than the discovered plates collected here. Tracking down the syndicated strips is made more difficult by the fact that Eisner & Iger's strips were not syndicated to major newspapers. Unable to compete with the major daily syndicates, the studio's affordable weekly strips were sold to small newspapers.

I have two orphaned tear sheets of printed *Harry Karry* strips in my collection dating from March and October of 1939, from a small Washington paper, the *Grays Harbor Post*. There each *Harry Karry* is paired with a *Micky and his Gang* strip by "Sam Iger," suggesting the two strips were syndicated in tandem.

Perhaps yellowing bound volumes of comparably obscure newspapers containing *Harry Karry* survive somewhere in libraries or archives. If a curious comics detective somehow tracks down a complete run of printed strips (or

syndicate proofs) we would know if any *Harry Karry* weekly strips were produced or syndicated beyond the cache discovered in the Joe Getsinger collection.

I suspect the syndicated continuity ends abruptly, as printed here, for a simple reason: as these strips were being syndicated, the Eisner half of the Eisner & Iger studio was about to leave the partnership. In late 1939, Everett "Busy" Arnold and the Register & Tribune Syndicate first approached Eisner about creating a weekly sixteen-page comic book insert that would become *The Spirit*, making its debut in June 1940. In a few short months Will Eisner's career was about to significantly spring forward and it is highly unlikely that during the transition period, neatly tying up the plot elements of *Harry Karry* would be among his concerns as he parted ways with his prickly partner Jerry Iger.

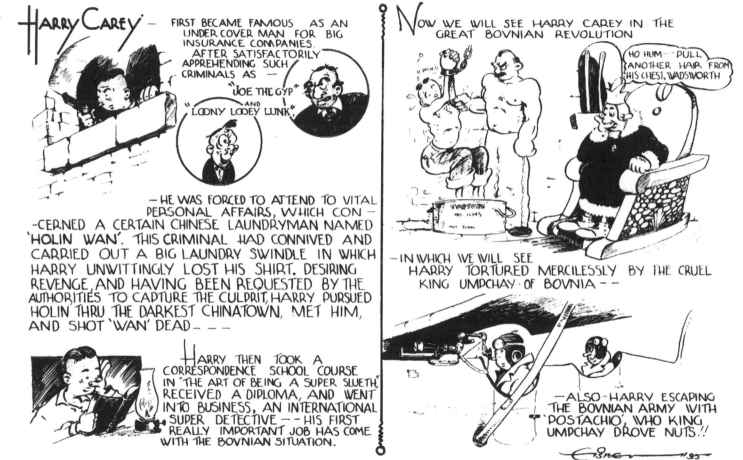

Eisner's very first *Harry* strip, published in the Dewitt Clinton High School newspaper.

The Getsinger Find

By Richard Greene

When Joe Getsinger first acquired the mountain of cartoon printing plates that would eventually come to be known as the "Getsinger Find," he did it on a hunch. He didn't know what kind of marvels the collection might hold. He just knew that, like a chunk of the library of Alexandria that had missed the fire, this massive collection of 1930s-era zinc plates had miraculously survived the scrap metal drives of the Second World War and somehow remained intact into the 21st century. And he knew he had a lot of research to do.

What he discovered would exceed his wildest dreams. The trove contained truly vital, revelatory pieces of unknown comic history, including profoundly interesting fragments of the past, lost in the sands of time: the cartooning equivalent of folios by a teenage Shakespeare, or the schoolbook scribbles of a post-adolescent Picasso.

The story of the Getsinger Find is a mixture of luck, perseverance, and detective work by an actual detective. Joe is a retired New Jersey State Police arson investigator with a sideline in visual art and printmaking. He's raised over $1 million for burn victims, veterans organizations, and police charities through the sale of fine art prints of his paintings. He's also been a fan of comic art since childhood, drawing cartoons all through high school and military service—so when Joe was approached at an annual poker game by his old friend David J. Russell about some old cartoon printing plates, his curiosity was piqued.

"Dave wasn't interested in researching what he had," says Getsinger, "so I made a deal to acquire them from him. It was sheer luck that I got these plates—when I called him he was getting ready to drive to Colorado, and he would have been halfway through Pennsylvania if I had called a couple hours later. He suggested I bring my truck, but I didn't understand why—until we met and it turned out there were forty boxes of these things."

Russell confided that the 5,000-some plates had been purchased from a man named Charles Rose, who had sold the lot to Russell and another collector named E.G. Marshall in 2006. Ever the completist, Joe next reached out to Marshall and negotiated the purchase of his portion of the plates. That reunited collection of 8,800 printing plates was soon fittingly dubbed the "Getsinger Find."

Joe began to organize and research the plates, compiling a list of the cartoonists who authored them. He became particularly intrigued by a noir/spy strip called *Harry Karry*, credited to an unknown artist named Willis B. Rensie.

"I was looking at a reverse-printed *Harry Karry* plate and it came to me in a flash: 'Rensie' was Eisner spelled backwards!" says Joe. Subsequent research revealed that Rensie was a pen name that the great master of cartooning Will Eisner frequently used in his youth, including on his earliest collected work (until now!), the serial pirate strip *Hawks of the Seas*.

The next step was to try to place the strips in the historical context of Eisner's career. "Everything started really clicking when I also found plates by Samuel Maxwell Iger, and realized this collection was somehow connected to the Eisner and Iger Studio," Joe says. Eisner

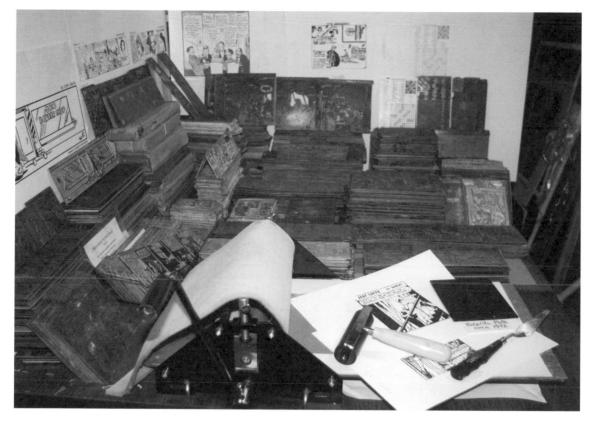

and Iger had started out together in 1936, working on the short-lived publication *WOW, What a Magazine!* before founding their own small company (Eisner and Iger Studio, or Eisner & Iger) to distribute their cartoons and strips. In their early years they used various pen names, so that Eisner & Iger would appear to be a thriving studio with many artists in its employ. Iger created cartoons under pseudonyms such as Maxwell, Regi, and S.M. Iger. In addition to Willis B. Rensie,

Eisner also went by both Erwin and Carl Heck—as he is credited on the *Uncle Otto* strips also included in the Getsinger Find. These names, along with the Eisner & Iger connection, placed the distribution of this material between 1936 and 1939, at the very dawn of Eisner's career.

Now realizing that his collection seemed to contain undiscovered early strips by one of the true masters and pioneers of American comics, Joe redoubled his research efforts. With his detective instincts kicking in, he tracked down Charles Rose and took him out to dinner, picking his brain about the provenance of the collection.

The plates, Joe learned, had originally been the property of a distribution syndicate dating back to the 19th century known variously as The American Melody Company, The Meyers List, Empire Features, and International Cartoons. These names appear on labels on the backs of many of the plates. Eisner and Iger Studio was one of the syndicate's numerous clients, supplying cartoon materials for publication in American newspapers, most of which were small-circulation

weeklies. Plates in Joe's collection feature many cartoons by Eisner and Iger Studio artists such as Ruth Roche and Bob Kane (Eisner's high school buddy and co-creator of *Batman*), alongside countless other popular artists—Jack Kirby (under various pen names), Pat Little, Oscar Hitt, Morris Weiss (of *Mickey Finn* fame), Rube Weiss, Horace T. Elmo, Bert Link, Art Helfant, Hy Gage, Thornton Fisher, Ad Carter, Lee Bryan, Frank Webb, Uncle Cobb Shinn, John Harvey Furbay, PhD, and more.

In the 1930s the Meyers List was owned by J.R. Kramer, Charles Rose's father-in-law, who worked directly with Eisner & Iger as distributor of their strips. Rose and his wife bought the company and all of its holdings (including such ephemera as these now-obsolete cartoon printing plates) from Kramer in 1967. Though the syndicate went bankrupt in 1998, the bulk of these historically interesting artifacts had been sitting in Rose's garage until 2006, when they were finally sold off to David J. Russell and E.G. Marshall.

At this point in his research, Joe decided to call in reinforcements—he reached out to me, an old family friend. As a cartoon art collector and comics historian, I was immediately enthralled by the remarkable treasure Joe had acquired and the thorough detective work he'd done. I helped him contact others in the comics community, such as Eisner's publisher and agent Denis Kitchen, and locate institutions around the country, such as the Billy Ireland Cartoon Library at Ohio State University, which held archives of some of the scattered local papers in

which the *Harry Karry* and *Uncle Otto* strips had been published. This proved crucial to filling in a few missing strips, and establishing that they were indeed, at this point, in the public domain. I also put him in touch with the Eisner and Harvey Award-winning Philadelphia small press Locust Moon, who got Will Eisner Studios and the Eisner estate on board with the project, and produced this beautiful volume.

Finally, and perhaps most laboriously, Joe called upon his old high school print-shop skills to turn these tarnished zinc plates into images ready for publication. They had to be mounted, inked, printed on a proofing press, and cleaned—at which point the prints could be scanned and digitally logged. A messy, manual, and time consuming process.

The true and full significance of the Getsinger Find, and of the very Eisner strips collected in this book, will only be revealed as these plates are made available to scholars and researchers who will piece together the myriad connections between the various artists, their syndication histories, and the works for which they are better known. It's my belief that the Getsinger Find is a rich vein of comic history, and these strips are just the tip of the iceberg.

But for now, I'm honored to help present these fascinating and revelatory pieces of the Will Eisner puzzle, reclaimed from the ash heap of history. We hope that you enjoy reading them as much as we enjoyed finding and investigating them.

13

Uncle Otto

Will Eisner's *Uncle Otto*, a series of stand-alone cartoons published in the 1930s under the name "Carl Heck," represents a very interesting path that he never traveled much further down. Though Eisner would return at times to single panel gags, this kind of quasi-clear line cartooning and vaudeville style of comedy is unlike most of the rest of his work. As Denis Kitchen remarks in his introduction, it bears a striking visual resemblance to the also-silent strip *The Little King*, which had become a hit in the years just prior to the creation of these images. The title *Uncle Otto* may in fact even be a reference to *The Little King*'s creator Otto Soglow.

The strip's quality varies wildly, in both humorous and artistic execution. Some of the drawings appear very loose and gestural,

even dashed off and sloppy, while others have a smooth, highly appealing, fully developed art style. This may be a result of deadline pressures causing Eisner to sometimes churn out half-baked ideas and drawings, or may be evidence that he subcontracted some of this work out to studio assistants.

We have thus far found no evidence of *Uncle Otto*'s publication in any newspaper. However, the character of Otto was featured (alongside Harry "Carey") in several issues of *Jumbo Comics*, a magazine that compiled daily and Sunday strips, published by Fiction House in 1938 and 1939. Eisner does not appear to have returned to the character or this particular art style following the dissolution of Eisner and Iger Studios, but a handful of these strips were reprinted in the 1950s in *All Top Comics*.

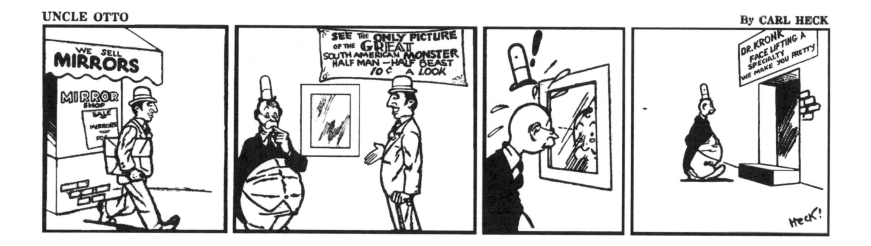

UNCLE OTTO By CARL HECK

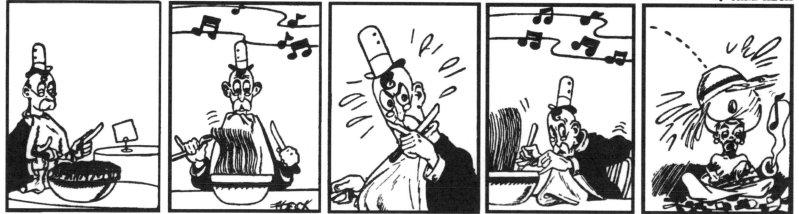

UNCLE OTTO

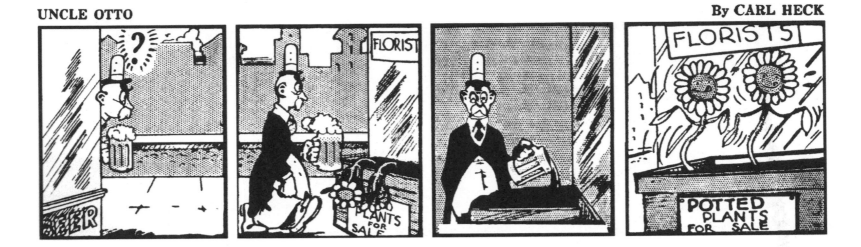

UNCLE OTTO

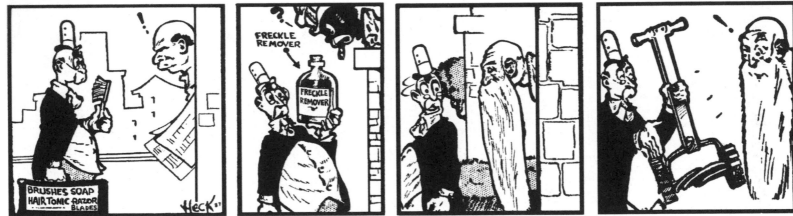

THE LOST WORK OF WILL EISNER

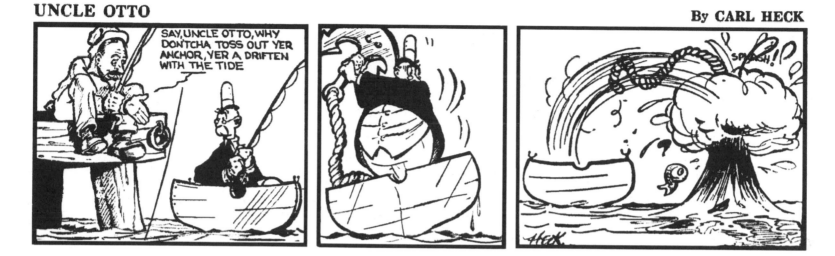

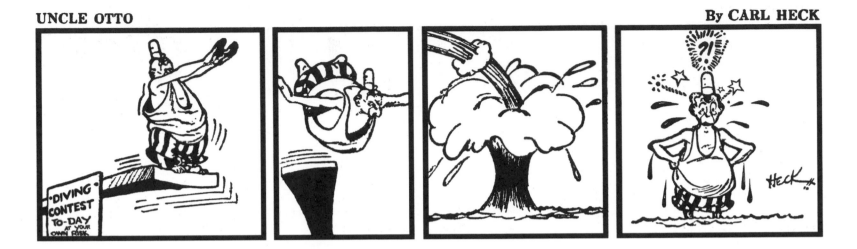

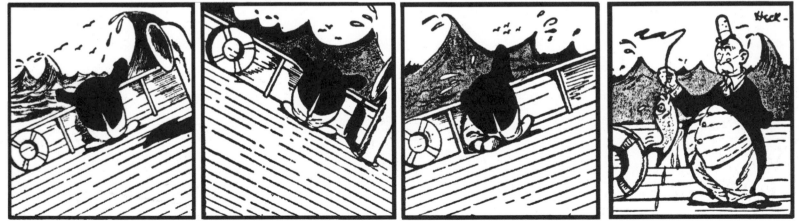

The Lost Work of Will Eisner

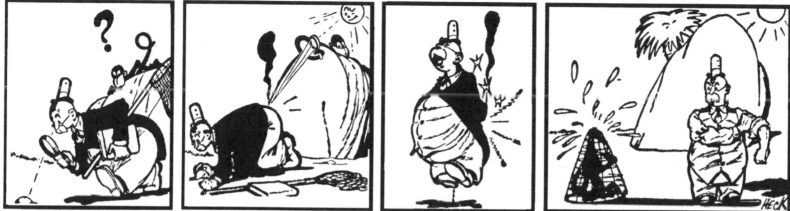

UNCLE OTTO

By CARL HECK

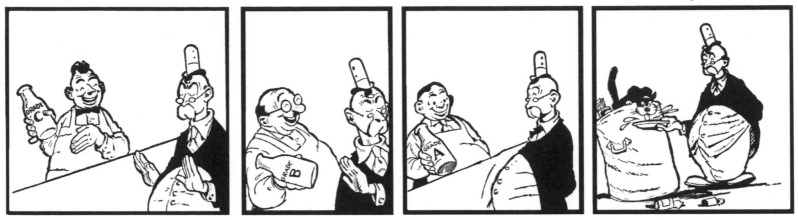

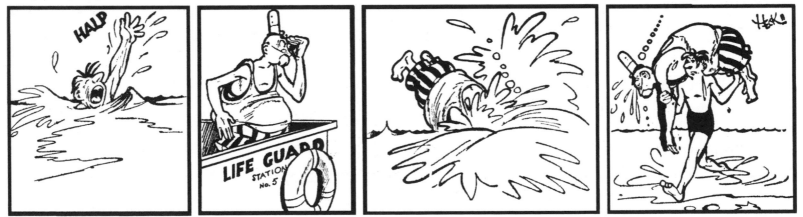

The Lost Work of Will Eisner

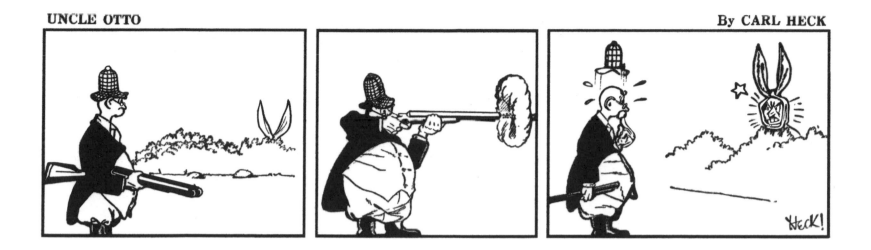

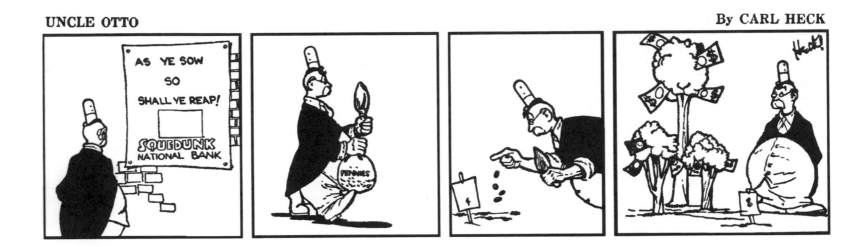

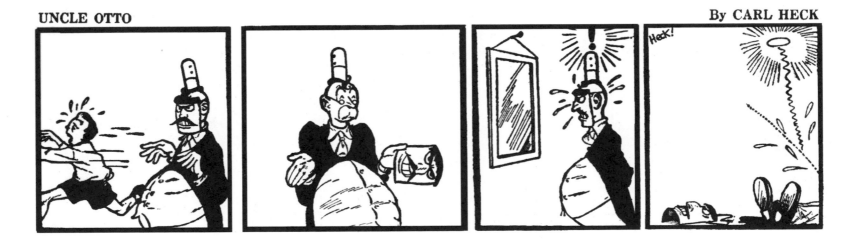

THE LOST WORK OF WILL EISNER

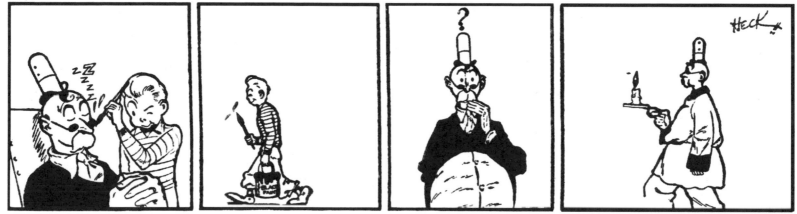

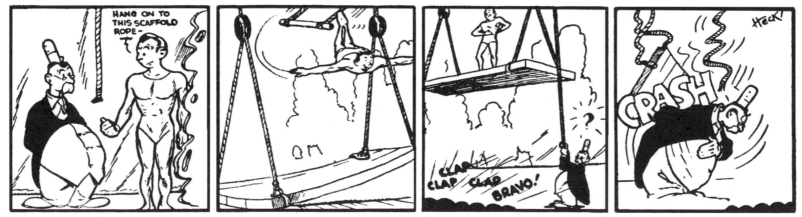

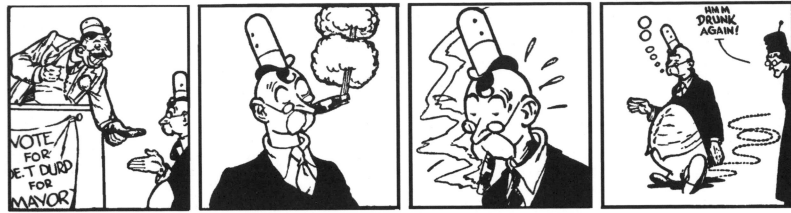

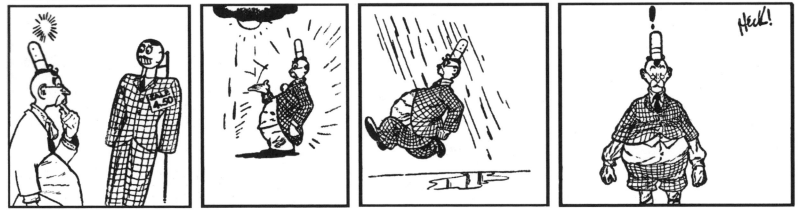

The Lost Work of Will Eisner

UNCLE OTTO

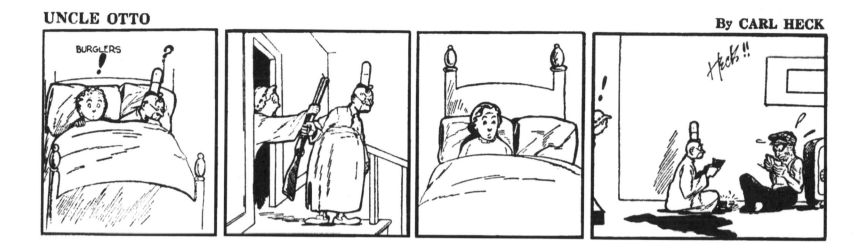

UNCLE OTTO

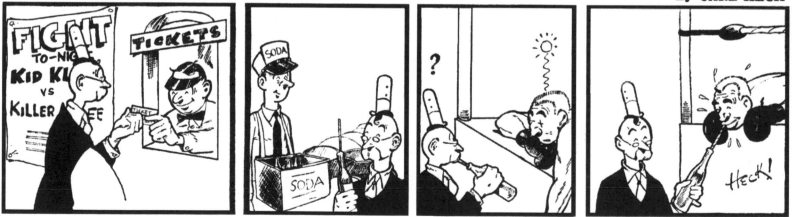

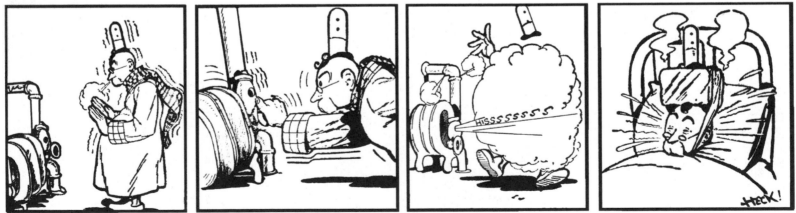

UNCLE OTTO

By CARL HECK

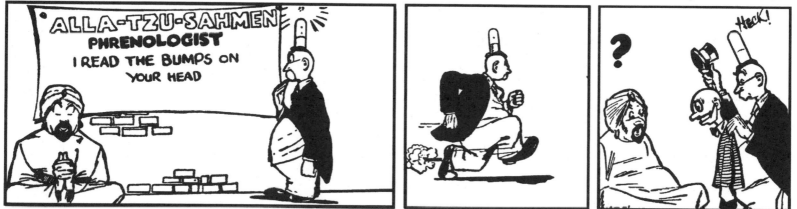

UNCLE OTTO

By CARL HECK

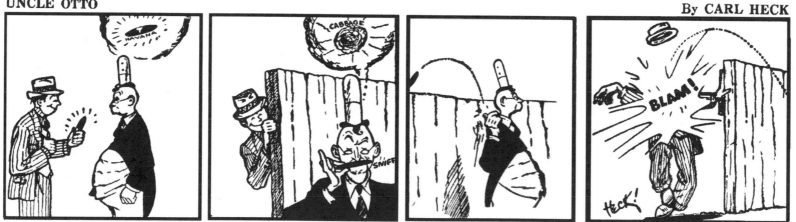

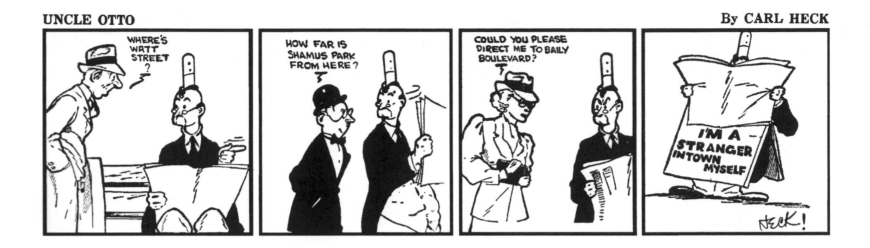

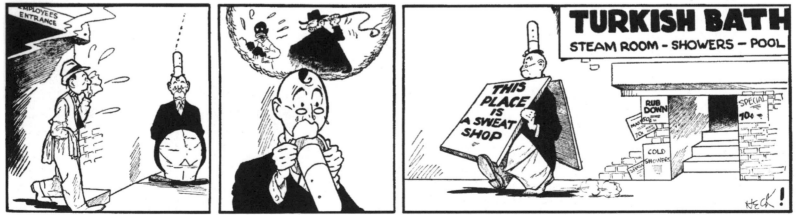

The Lost Work of Will Eisner

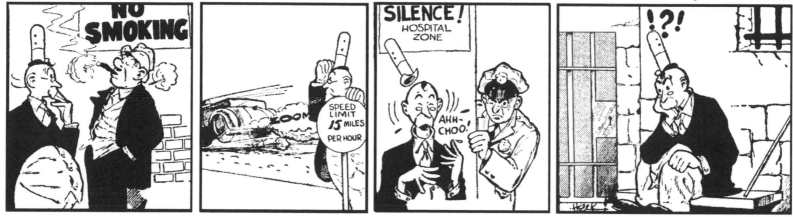

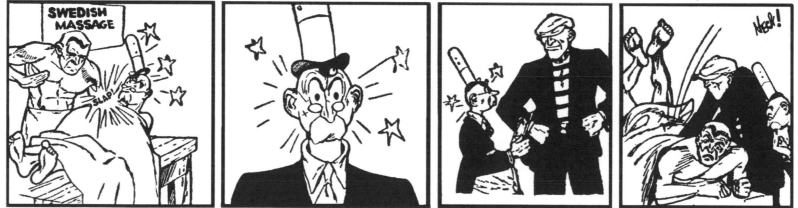

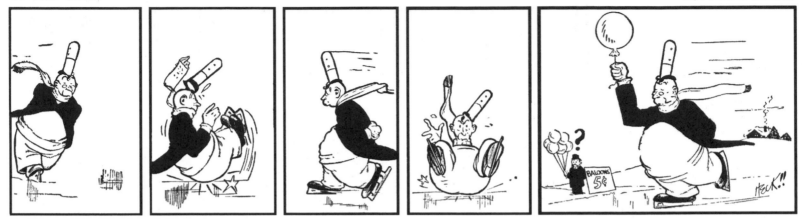

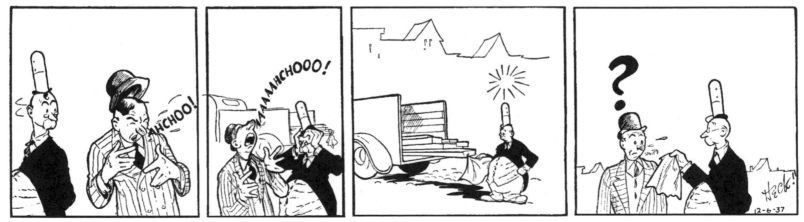

THE LOST WORK OF WILL EISNER

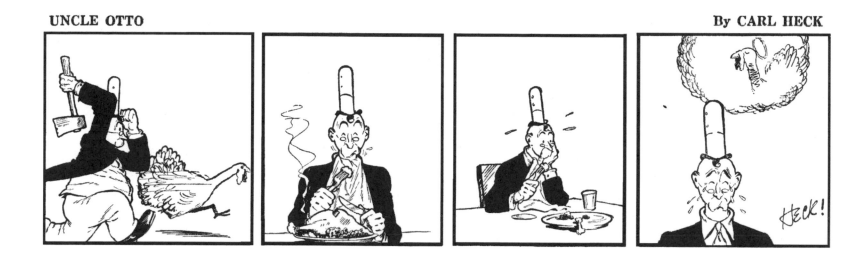

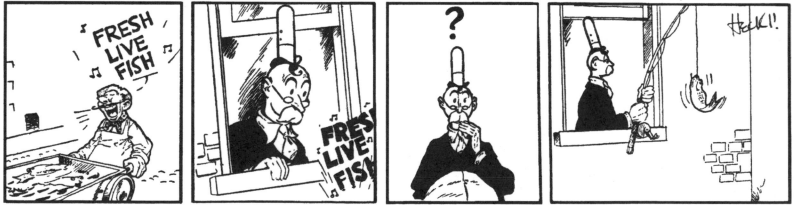

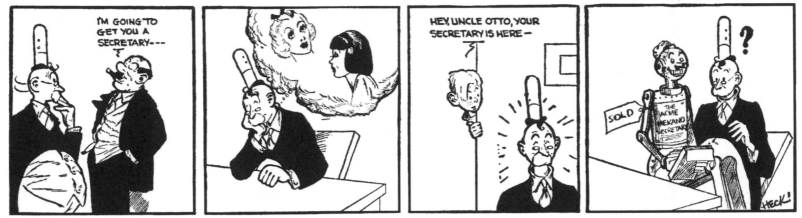

UNCLE OTTO
By CARL HECK

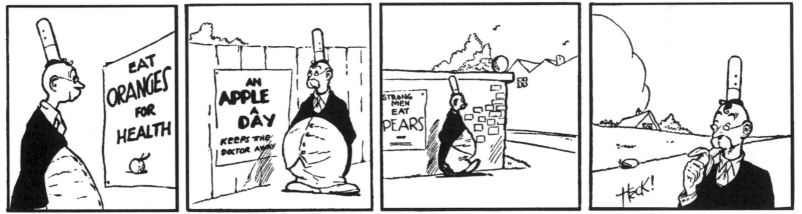

THE LOST WORK OF WILL EISNER

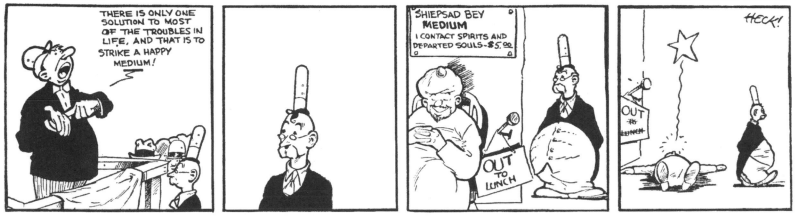

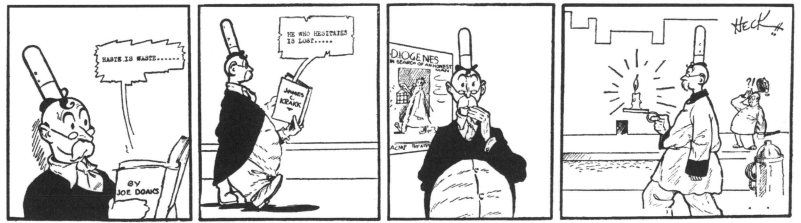

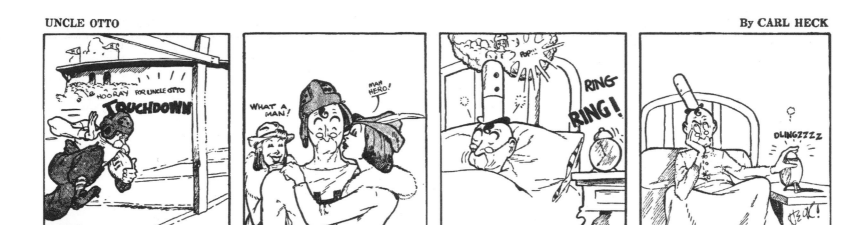

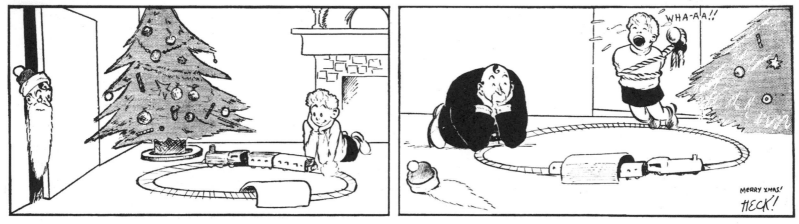

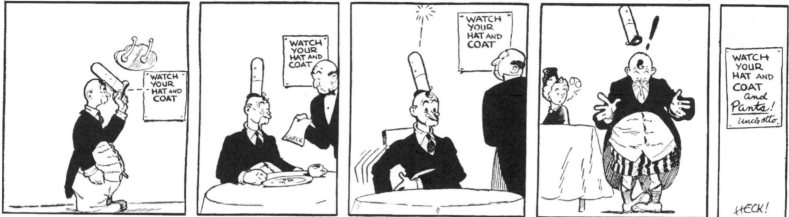

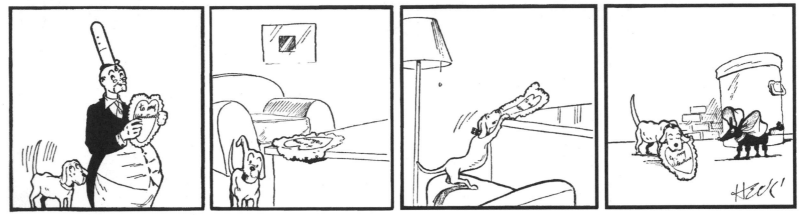

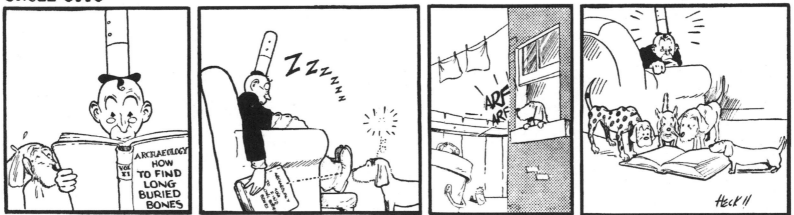

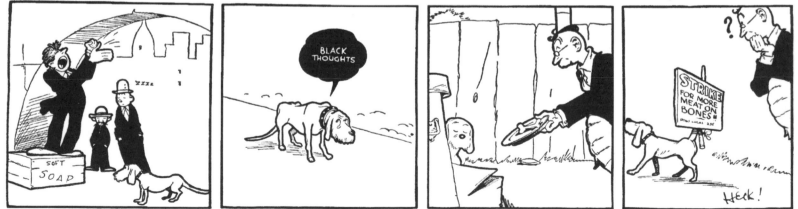

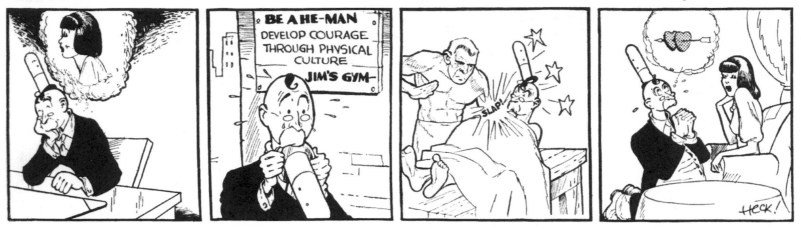

UNCLE OTTO By CARL HECK

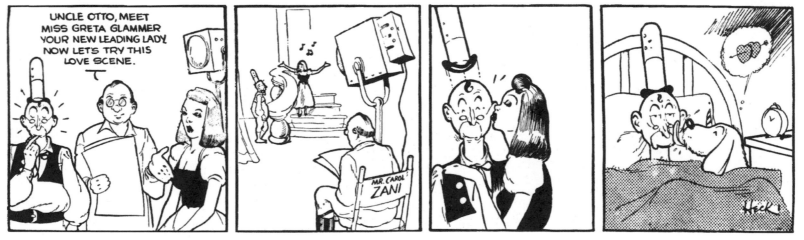

By CARL HECK

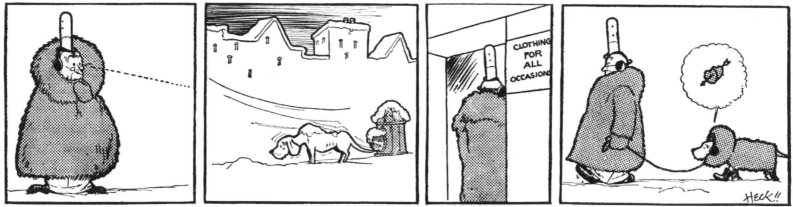

UNCLE OTTO

By CARL HECK

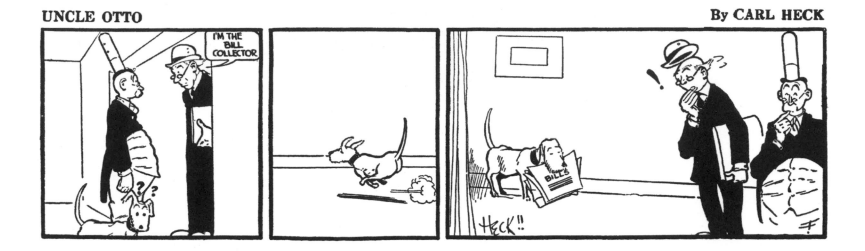

UNCLE OTTO By CARL HECK

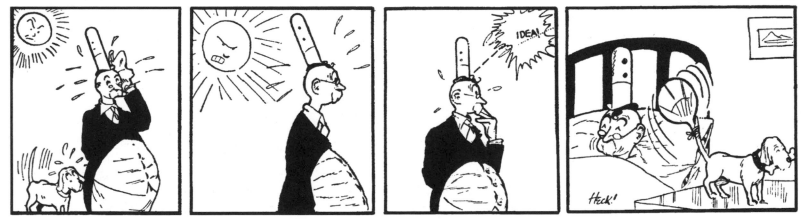

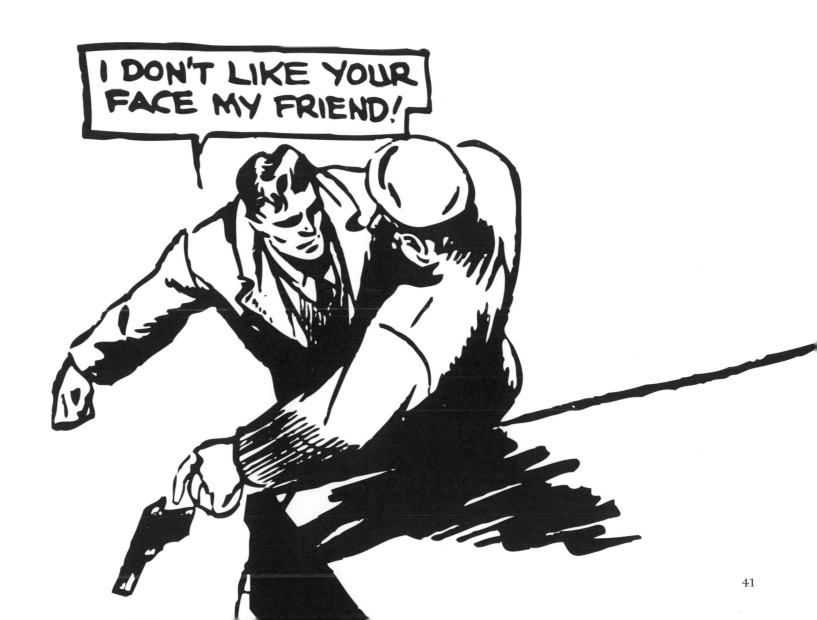

Harry Karry

Harry Karry, which went through several titles over the course of the 1930s including *Harry Carey* and *ZX-5*, seems to be Will Eisner's first published comic strip. It began as a slapstick take on the spy serial, heavily influenced by *Popeye* creator Elzie (E.C.) Segar, and first appeared in Eisner's DeWitt Clinton High School newspaper. It then ran in the short-lived *WOW, What a Magazine!* in full-color, single-page, tabloid style chapters, and was later collected in *Jumbo Comics*. Through *WOW, What a Magazine!*, Eisner met Jerry Iger, and together they formed the Eisner and Iger Studio, which syndicated the strips collected in this book to various local newspapers through Empire Features.

Early in the syndicated series of *Harry Karry* strips, the mode of art and storytelling undergoes a sudden and seismic change: within one strip, in the space between panels, Eisner drops the slapstick comedy and adopts a new, more serious tone and a dry brush art style reminiscent of popular cartoonist Alex Raymond. Through a breakneck series of plot developments and visual choices, we can see Eisner gradually developing into the artist who would soon create *The Spirit*, in 1941. When Agent ZX-5, the square-jawed secret agent who replaces the eponymous protagonist of the strip, dons a domino mask in order to disguise himself, it is impossible not to see the first shades of Denny Colt's storied alter ego. In these strips, we see an extraordinarily talented young man feeling around, exploring his influences, and slowly but surely finding the bold and booming voice that would inspire every subsequent generation of cartoonists.

HARRY KARRY

By WILLIS B. RENSIE

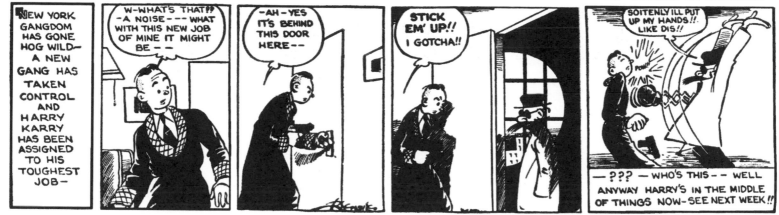

HARRY KARRY

By WILLIS B. RENSIE

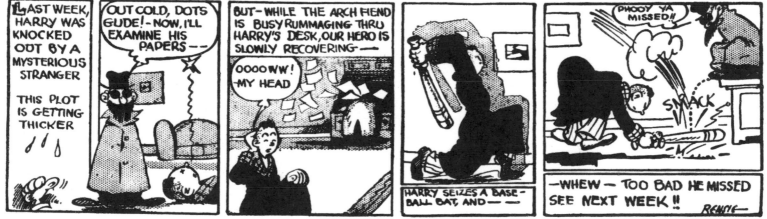

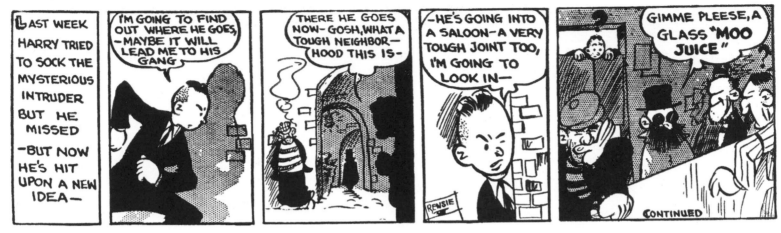

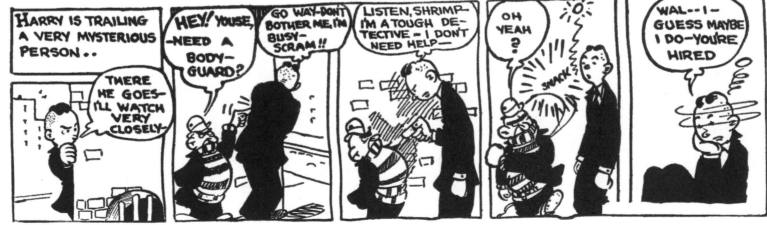

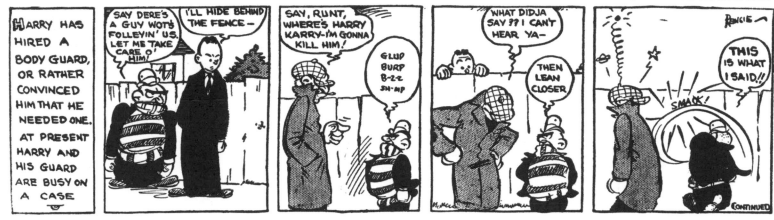

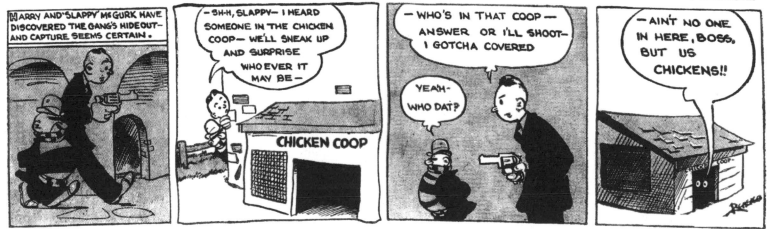

HARRY KARRY

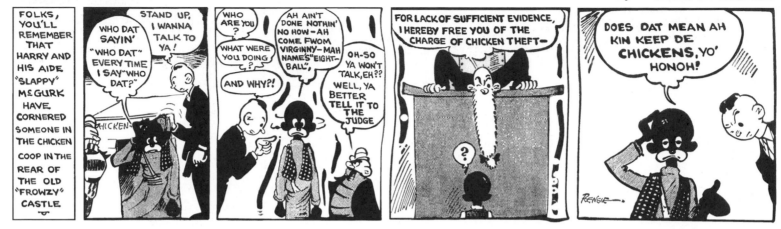

HARRY KARRY

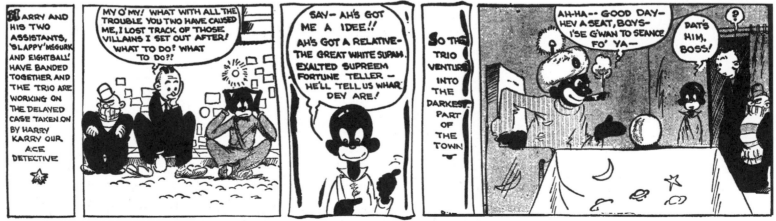

HARRY KARRY

By WILLIS B. RENSIE

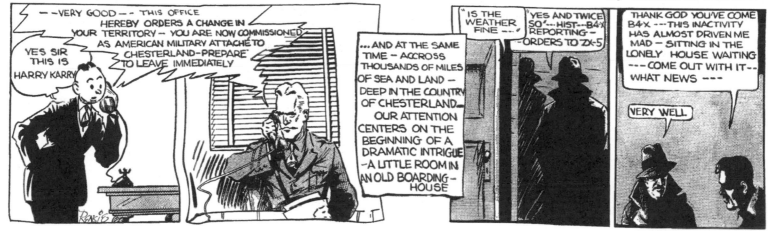

HARRY KARRY

By WILLIS B. RENSIE

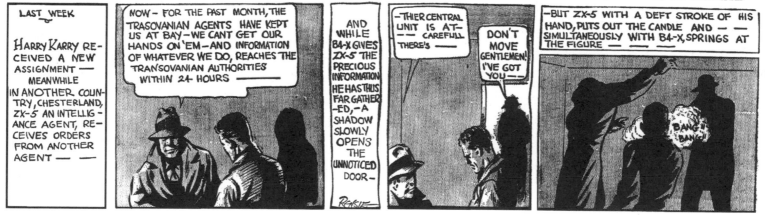

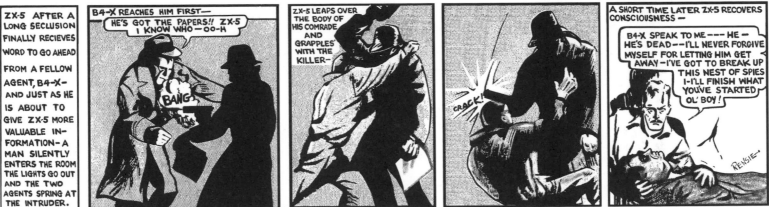

The one missing plate from Getsinger's collection. This strip was reconstructed from an image found in the Newspaper Archive.

HARRY KARRY

By WILLIS B. RENSIE

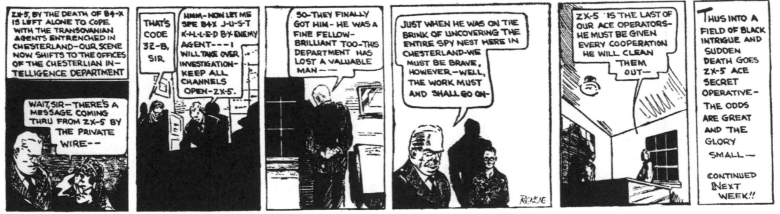

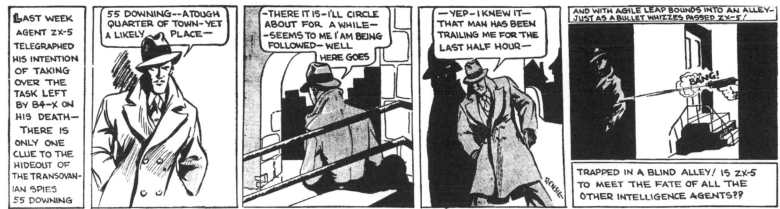

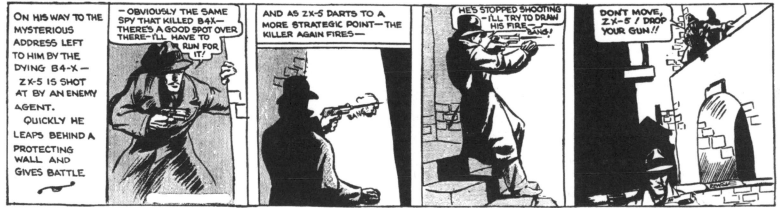

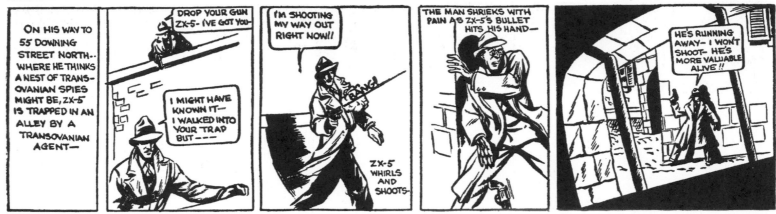

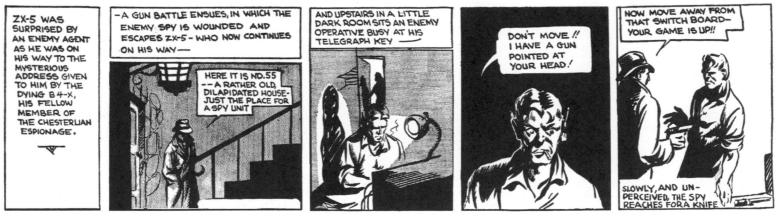

HARRY KARRY

By WILLIS B. RENSIE

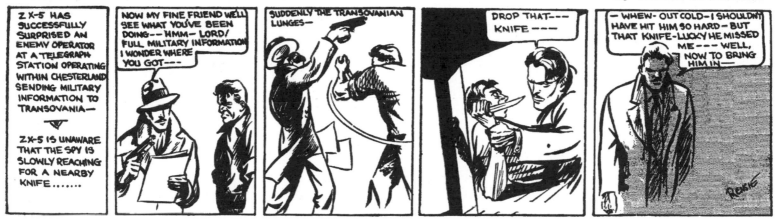

HARRY KARRY

By WILLIS B. RENSIE

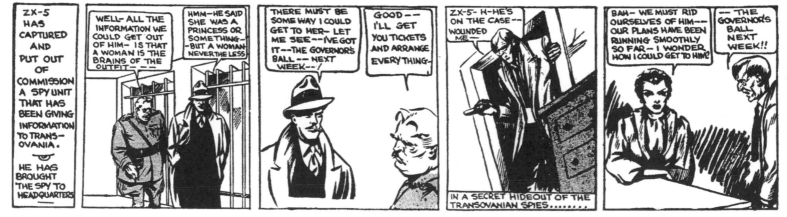

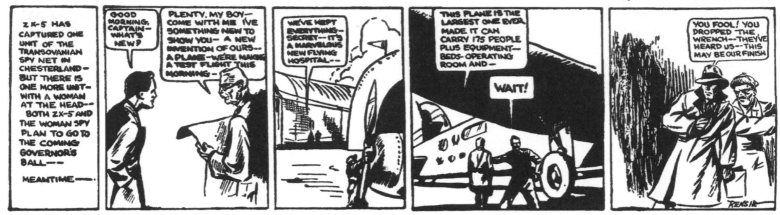

HARRY KARRY By WILLIS B. RENSIE

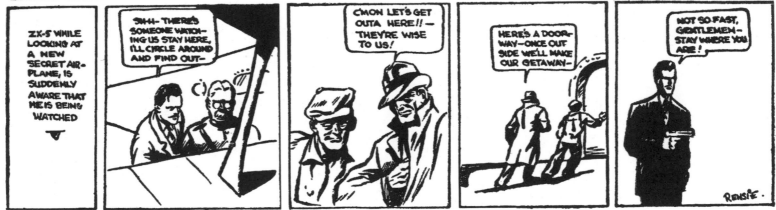

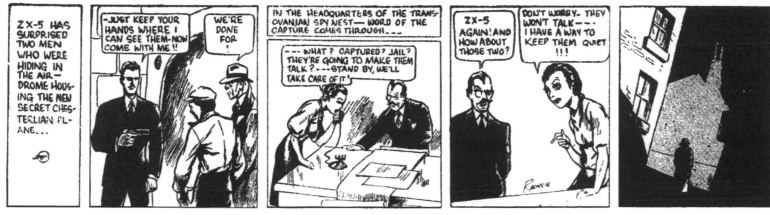

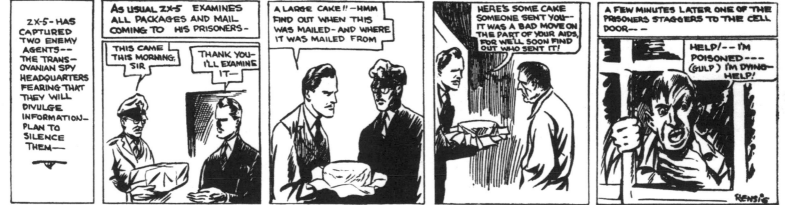

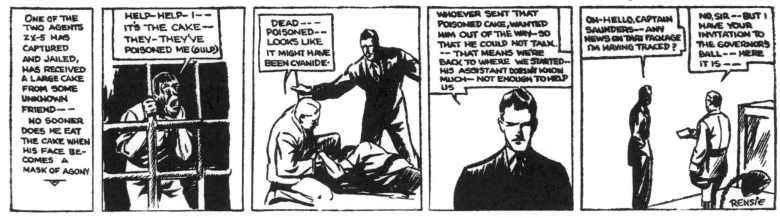

HARRY KARRY By WILLIS B. RENSIE

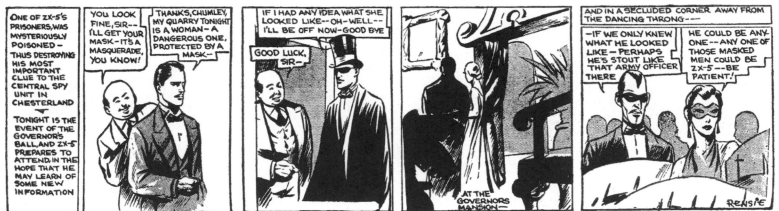

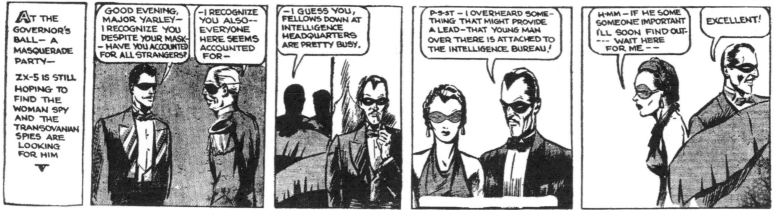

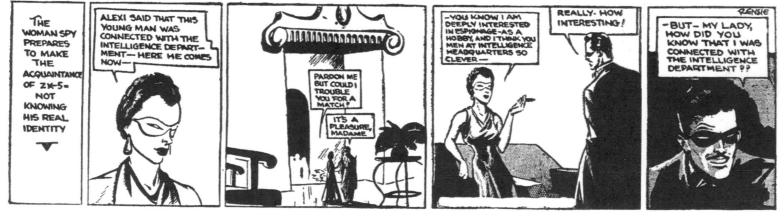

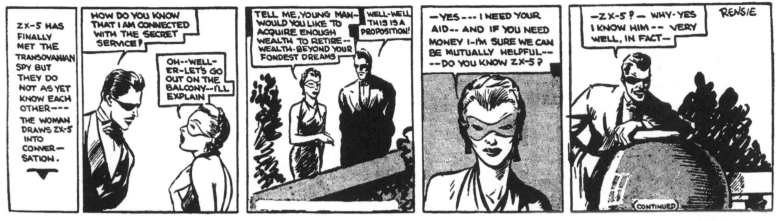

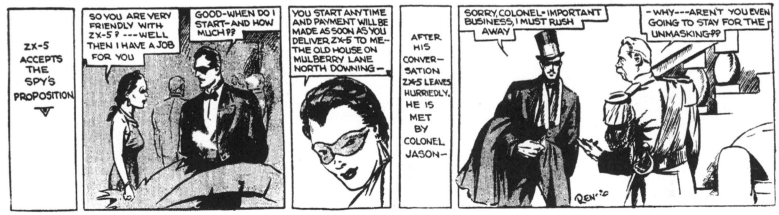

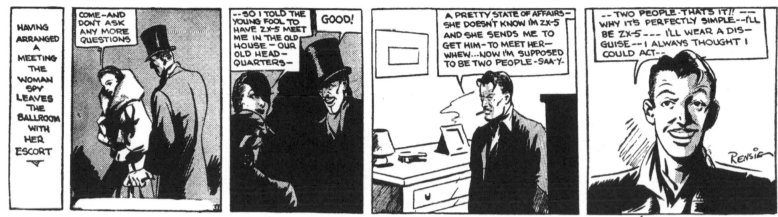

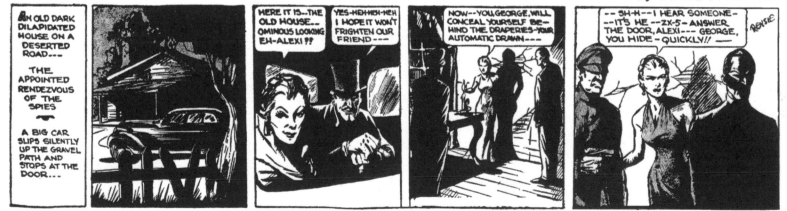

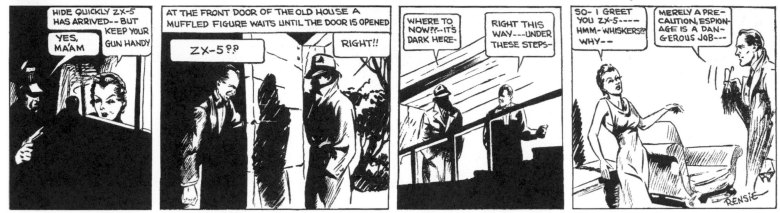

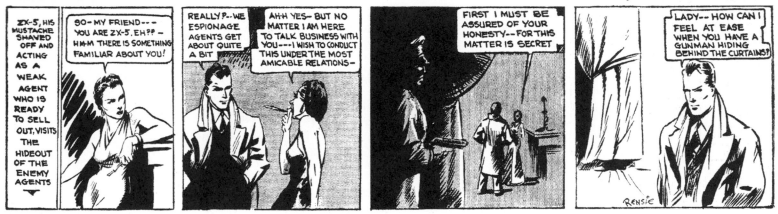

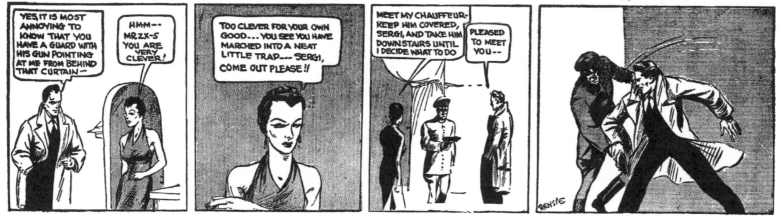

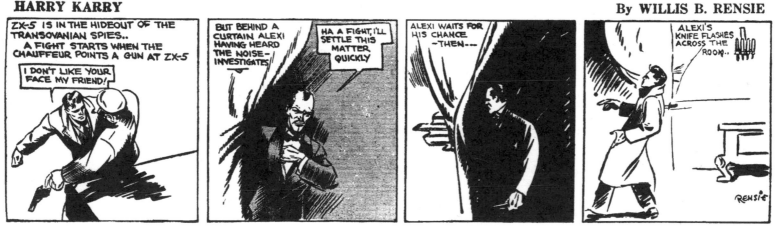

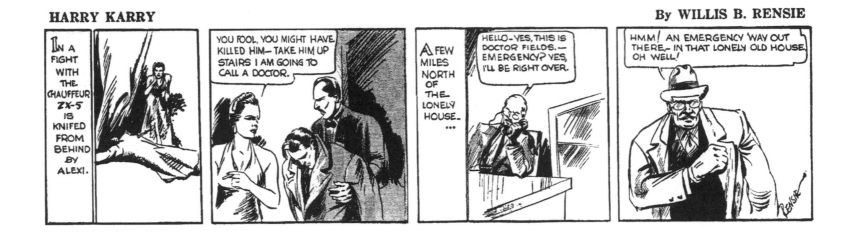

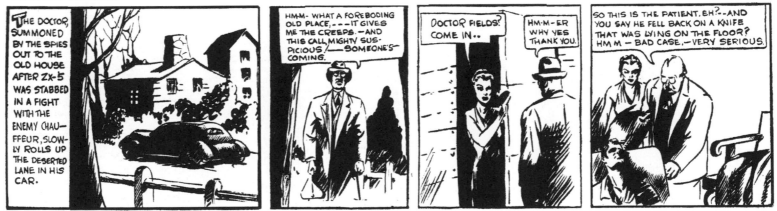

HARRY KARRY

By WILLIS B. RENSIE

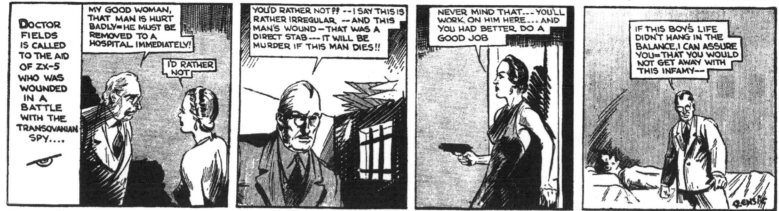

HARRY KARRY

By WILLIS B. RENSIE

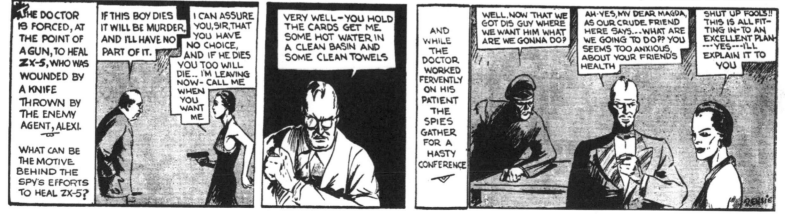

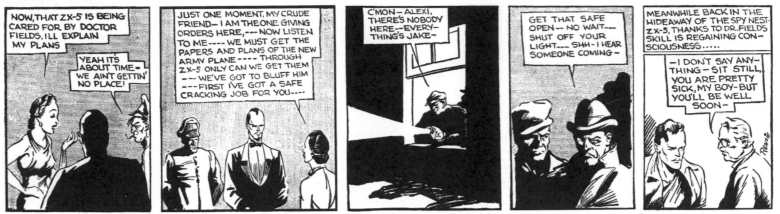

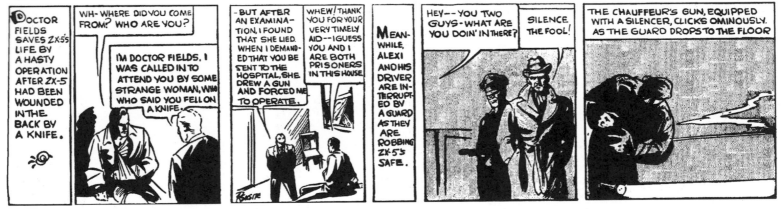

HARRY KARRY

By WILLIS B. RENSIE

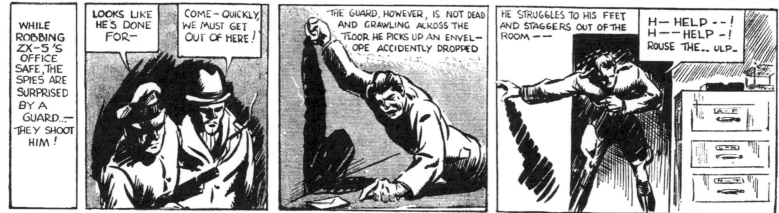

HARRY KARRY

By WILLIS B. RENSIE

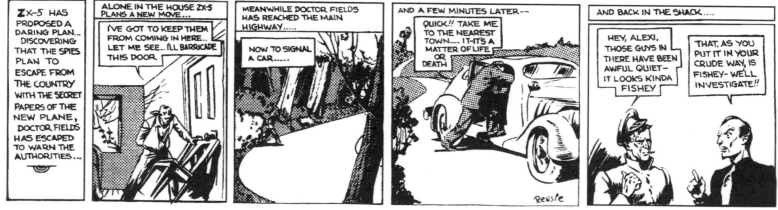

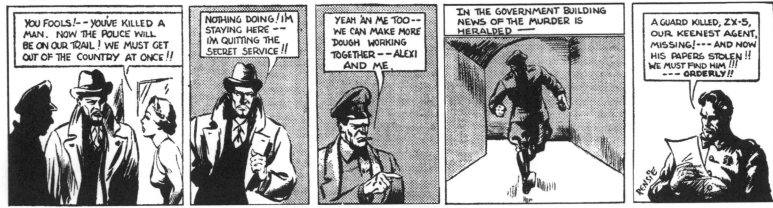

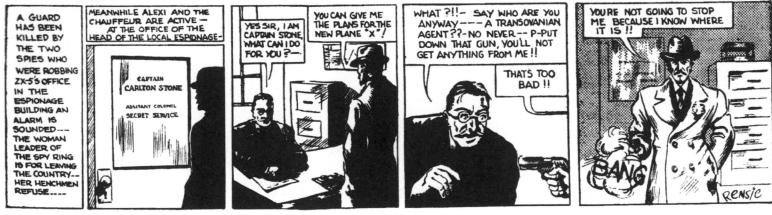

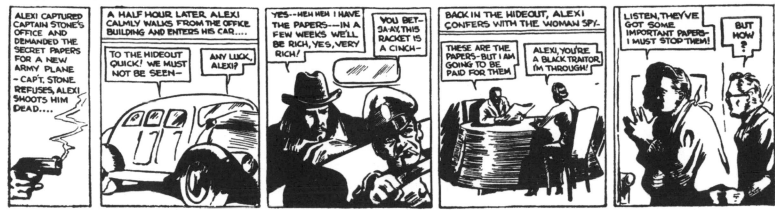

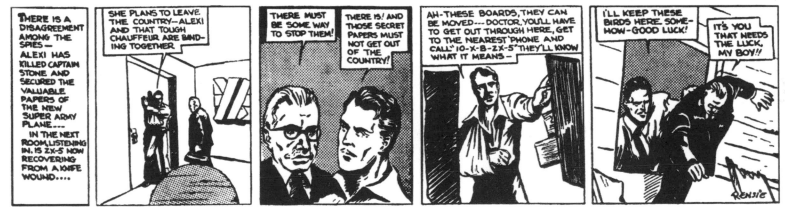

HARRY KARRY

By WILLIS B. RENSIE

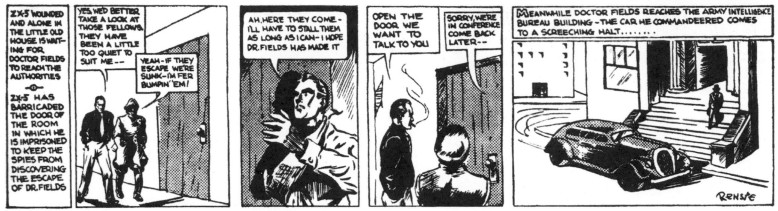

HARRY KARRY

By WILLIS B. RENSIE

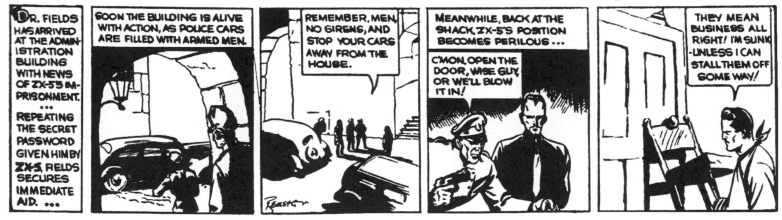

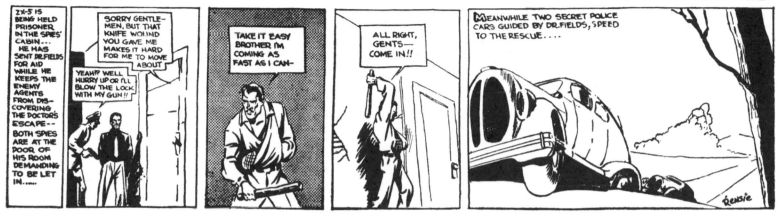

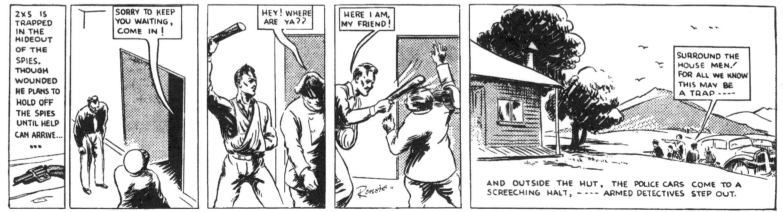

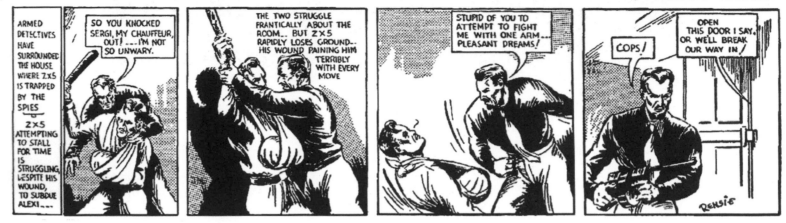

The Lost Work of Will Eisner

Will Eisner is one of the true giants of comics history. Between his birth in 1917 and death in 2005, he revolutionized the medium time and time again, expanding the possibilities of visual storytelling and sequential art (a term he coined), and pioneering the concept of the now ubiquitous graphic novel.

He was breaking new ground by his early twenties with his popular newspaper strip *The Spirit* (starting in 1940), which was noted for its experiments in content and form. He created dozens of beloved and enduring characters, such as Denny Colt, John Law, Lady Luck, Mr. Mystic, Uncle Sam, Blackhawk, Sheena, and countless others.

A vital and engaged artist throughout his remarkable life, his career featured a triumphant third act in the 1970s and '80s in which he experimented with underground distribution, released a string of startling graphic novels including *A Contract with God*, *A Life Force*, and *To the Heart of the Storm*, works of a kind of ambition and literary heft then-unprecedented in comics, and helped invent the field of comic studies with his book *Comics and Sequential Art*.

The Will Eisner Award, the most prestigious award in the comics industry, was named in his honor. He was, unsurprisingly, one of the inaugural inductees into the Will Eisner Comic Book Hall of Fame.

Thank You!

Rafer Roberts, Tom and Tara Alexander, Andrew Pepoy, Garrick Dietze, Karen Green, Kendall Whitehouse, Gregory Benton, Neil Gaiman, Vincent Kukua, David Macho, Emily Beauparlant, Jon B. Cooke, Ursula Murray Husted, M. C. Matz, Jack Chiu, Daniel Loyd + Fiona Ferguson-Loyd (10/08/16), L Jamal Walton, The Love Family, Aaron Kessel, Violet LeVoit, Erik Harker, Jason Tippitt, Rob Salkowitz, Rich Clabaugh, Mark Newman, Brian Berkey, Joseph D. Rodriguez, Cory Sedlmeier, John Schwengler, Ryan Zlomek, Daniel H. Segall, Colin Goh, Jay Lender, Becky O'Neill, Mike DeLisa, Rob Cairns, Dimas da Silva Mützenberg, Elizabeth Faust, Sascha-M. Dörp, Jascha Buder, Wladimir, Maureen Grey, Forrest Snyder, Cang Ling Yee, Arthur Tuchfeld, Marko, Cheryl Sundseth, Doug Schaefer, Steve Kalkwarf, Scott Kawczynski, C. van Leeuwen, Grendel70, Tom Phillips, Peter Giakoumis, Robert Andrews, Steve Viens, J. Kenneth Riviere, Dale B. Miller, Mark Saskin, Johnson Hor, Hal Bryan, Christoffer Klang, Gene Evans, Imre Balogh, Gary Grady, Pablo Aumente Gallego, Alex, James Leonard Franklin, Rikard Hedberg, mk, Alan Gassner, Joseph Gialluca, werwolf, Nancy Paisley, Rene Polin, Carlos Terra, Eric Johnson, Jacques-Andre Blouin, Raynardo Shedrick Jr., Michel Olivieri, Shingo Nishimura, Kevin Bostwick, John L. and Marybess D. Goeppinger, Mark Peetz, Andrew Youngmeister, Dana Thoms, Ron Lauzon, Tiff Hudson, Annalee Seiber, Niki Pentland, Daniel J. Dobruse, Csaba Szigetvári, Tim Pilcher, Adam Reyes, Dylan Kurlansky, Dan Kimball, Heidi Robbins, Cat Myers, Petter Åhbeck, LynnMarie Panzarino, L. Anthony Becker, John Forsyth, Richard Raghoo, Nancy Fornoville, D. Rex Long, Kerstin Beau, Harris Smith, Abby, Michael Niklasson, TimeSeeker, John Brainard, Jonathan Bret Hendon, Jake Smith, Patrick Gurgel, Rob Price, David Samuelson, Zeinrich, Tobias Lind, Rex Michael Dillon, Ken Gregory, Tommy Baldwin, Stefano Morelli, Mary Mongold, Comichaus.com, Yves Kerremans, Josh Rose, Patrick Ridings, Allan Palmer, Hircus Artifex, Ed Aycock, Greyson Nance, Noël Slangen, Geert-Jan Kruijff, Andy Lang, John Lancaster, Michael Gilstrap, Karl Reinsch, John Ver Linden, Jonas Wagner, Gene Kannenberg Jr., Garen Evans, Richard Loh Kern Liang, Zeke Hanson, Ricardo Contreras, Patrick Kelley, Nick Jones, Yoshi Kurosu, Timothy Cline, Daniel Pipito, Arnauld Steppé, Harvey O'Brien, Martim De Carvalho Leicand, James Edward Reed, Sean Frost, Justin Matlock, Pierce Lustig, Rick Mendoza, John O'Donnell, Gary Dunaier, Gary Simmons, David Moyes, Aaron P. Churchill, Jeffrey Katz, Bill Schelly, Rachel Tougas, Matthew Clement, Leigh Cramer, Mike Goffee, Scott Willems, Bob Andelman, Daniel Theodore, Miguel Ruiz, Mark Byzewski, Dominic Duggan, Peter Larsen, Randall Cyrenne, Rod Mearing, Allen Pinney, Germund von Wowern, Trevor Williams, Andrew Kunka, Forgerelli, Doug McCratic, Bruce MacKeen, Mary Hammond, Eunice H. Verstegen,

THE LOST WORK OF WILL EISNER

Bruce Schalcher, N. C. Christopher Couch, Valérie Lescrainier, Jack Abramowitz, Ryan Milakovich, James Manley, Jonathan R. Freed, Steve Gold, Sam R. Burnes, Paul Arpaia, Claudia Esteves, Albert Moy, Jan Skomakerstuen, RT, Kent Kennedy, Peter Martin, J. Douglas Wellington, Greg Trawinski, Ralph Bunker, Rob Paul, Bob Ting, David Ogden, Jennifer Isett, Stephen Sandoval, Thomas A. Servos, Derek Yao, Dave Skinner, Jill Weston, Jerome A. Dennis, Alexander Yucas, Curtis B. Edmundson, Les and Cathy Von Bargen, Mile High Comics, Scott and Cindy Kuntzelman, ET K, Darryl May, Dean Cripe, William L'Hommedieu, Derham Groves, Jason Abbott, Mike A. Goolsby, Mark L. Van Name, Markku Tyynela, Bas Wiering, Horst Grundmann, Fred Johnson, Torbjörn Nager, Marko Tyynela, Jarno Nordvall, Holger Brorsen, Pius Gruber, Jean-Pierre Laparre, Alexandre Blum, Sune, Alan Wright, King Heiple, John Caulkins, Jordi Ensign, Charles, Georgia Higley, Brian S. Weis, Laura and Kevin Owen, Martin Stensby, Jan Dirk Snel, Alan G. Raymond, Stephen "Quinn" Bayley, Roberta Leibovitz, Concetta M. Dugan, Julie Beaver, Lisa Larson, Smith Powell, Ron Kerwood, David S. Fruechting, Christian Monggaard, Heather Parra, Michael Dann, Bob Aultman, Brian Fried, Leonardo Pizzo, Henry G. Franke III, Donna Scanlon, J A Petery, Kari Maaren, Janet McGlynn, Alvin Ruthenberg, David Chamberlain, Zach Crawford, Argus, Richard Meehan, Wayne Hollis, Jørn Viljar Arnesen, Dave Lanphear, Alessandro Jannuzzi, Cris Edbauer, Daniel Bevilacqua Meireles, Mkobar, Peter L. Brown, Max Downing, Michael Tabachnick, Rachel, D.W. Kann, Peter Hartung Olsen, Jonathan Irvin, David C. Williams, Mike Shiner, Kevin Pebley, Stijn Christiaens, John Deemer, Angelia Pitman, Susylee Hendy, Kamikazi, Jordi Pastor Lacruz, Steve Keast, Karl Vancoppenolle, Andrew Wimsatt, Mark Sato, Paul Trimble, Jason Shumate, Florian Schiffmann, Agyde, Hiroyuki Suzuki, Stephane Lacoste, Steve Vance, R~, Philip Frey, Shepherd Celbach, EdEn, Eric Provost, Oscar "PDLP" Teijeiro, Eric Tibosch, Dr. Juan Antonio Martinez Lopez, Robert Riley-Mercado, Graham Tormey, Alan Henderson, Mike White, Rick Porras, Sandro Merg Vaz, Jeff Robelen, Ricardo Bárrig Jó, Lloyd Ellis, Chris Plakholm, Andrea Grilli, Ted Haycraft, Julian Quinonez, Lou Valenti, Douglas Candano, Todd Good, Shane K. Sowell, Becky Ballantine, Philip Cole, Darren Cahill, Marco Castagna, Stephanie Frieze, Jim M. Cripps, Peter Cooper, Diana Green, Tony Ward, Wan Ni Khoo, Lisa C. Manning, Iain Ross, Justin LoRusso, Nir Kazin, Henri Patricio, Zach Dietz, Eduardo Aguirre-Kuehl, Louis Cabral, Roy Leban, Barry Lopez, Ken Morley, Steve Rubin, Ákos Bedekovics, Wil Schaefer, Sordel, Lee Anderson, Chris Saunders, Robert F. Daniel, Andrew Lohmann, Mike Turner, Brent Richardson, Michael Steinhart, Fiona Nielsen, Randy Wood, Paolo Polesello, Hugh O'Neill, John Willis, Tania Batten, Susan L., Adam Juda, and Robert H. Lambert.